SHALOM COLORING III

Animals of the Bible

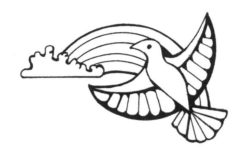

by

Judy Dick

with artwork by

Freddie Levin and Judy Dick

BEHRMAN HOUSE

www.behrmanhouse.com

*To all my friends who have encouraged and
helped me with this book, from bird-watchers to cat-lovers
to horse whisperers, and everyone in between.*
—JUDY

For Maggie
—FREDDIE

PROJECT EDITOR: Ann D. Koffsky
DESIGNER: Annemarie Redmond

Published by Behrman House, Inc.
Springfield, NJ 07081
www.behrmanhouse.com
ISBN: 978-0-87441-966-5
Printed in the United States of America

Art credits:
Cover by Judy Dick
Judy Dick: 2-11, 14-19, 22-27, 34-37, 42-43,
48-57, 62-65, 68-72
Freddie Levin: 12-13, 20-21, 28-33, 38-41,
44-47, 58-61, 66-67

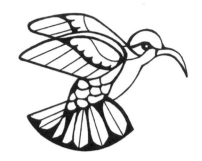

WELCOME TO
SHALOM COLORING III:
ANIMALS OF THE BIBLE!

The relationship between humans and the rest of the animal world begins from the moment Adam is charged with naming all the living creatures on earth. From Noah patiently caring for the animals on the ark, to Rebekah drawing water for camels, to Jonah being given refuge inside a whale, this special relationship continues throughout the Bible.

Hardworking oxen, jet black ravens, regal lions, and even humble ants all march through the pages of the Bible, each serving as powerful symbols from which we can learn. The Bible's descriptive language brings these animals to life. The illustrations in this book go one step further, presenting art inspired by the animals of these texts. Now it's your turn: use your own creativity to complete these artworks.

Choose tools that will best help you express your creative vision: colored pencils, watercolors, gel pens, or brush markers will all work well. Try choosing colors found in the magnificent animal world, from the tawny yellows and browns of desert animals, to the iridescent blues and purples of sea creatures. Or let your imagination go wild and dress your animals in hues of all shades.

Enjoy yourself; relax into the beautiful designs and patterns inspired by the biblical quotes in these pages. Let them bring you calm and contentment, joy and happiness.

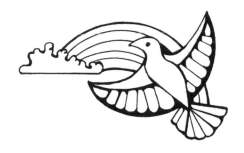

How many are the things
You have made, O Lord;
You have made them all with wisdom;
the earth is full of Your creations.

—Psalms 104:24

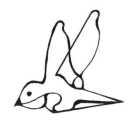

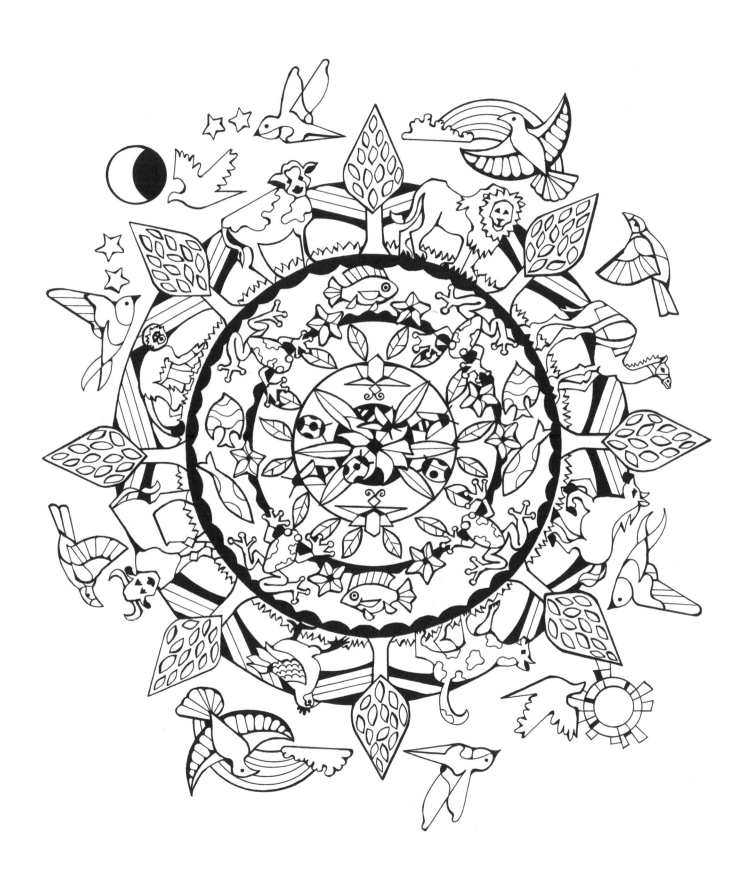

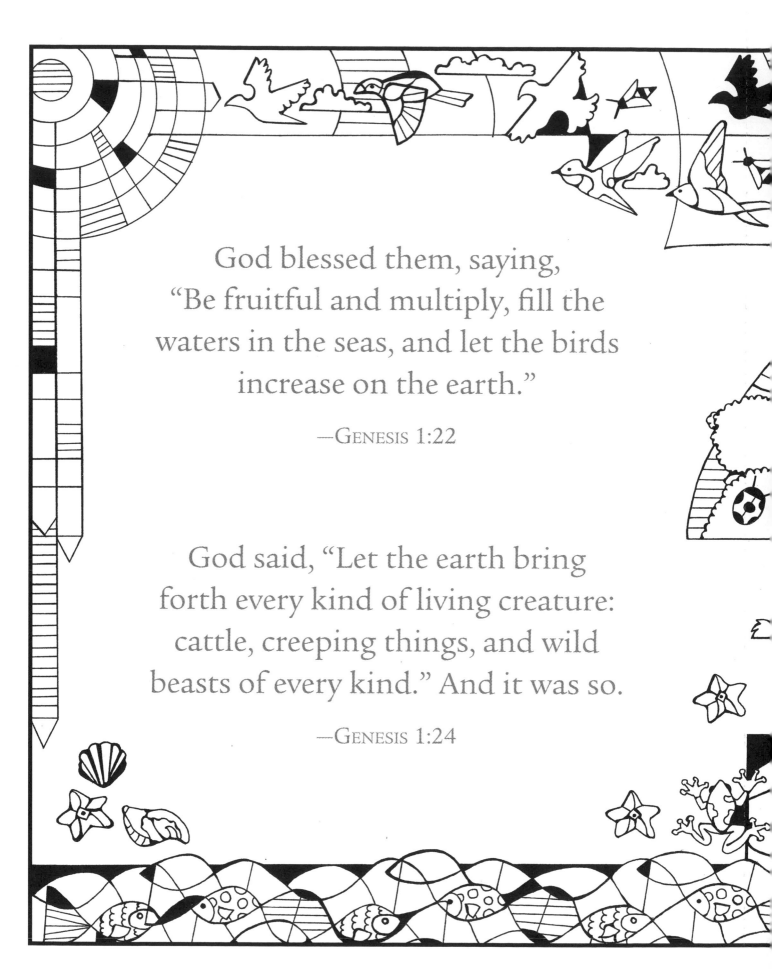

God blessed them, saying,
"Be fruitful and multiply, fill the
waters in the seas, and let the birds
increase on the earth."

—Genesis 1:22

God said, "Let the earth bring
forth every kind of living creature:
cattle, creeping things, and wild
beasts of every kind." And it was so.

—Genesis 1:24

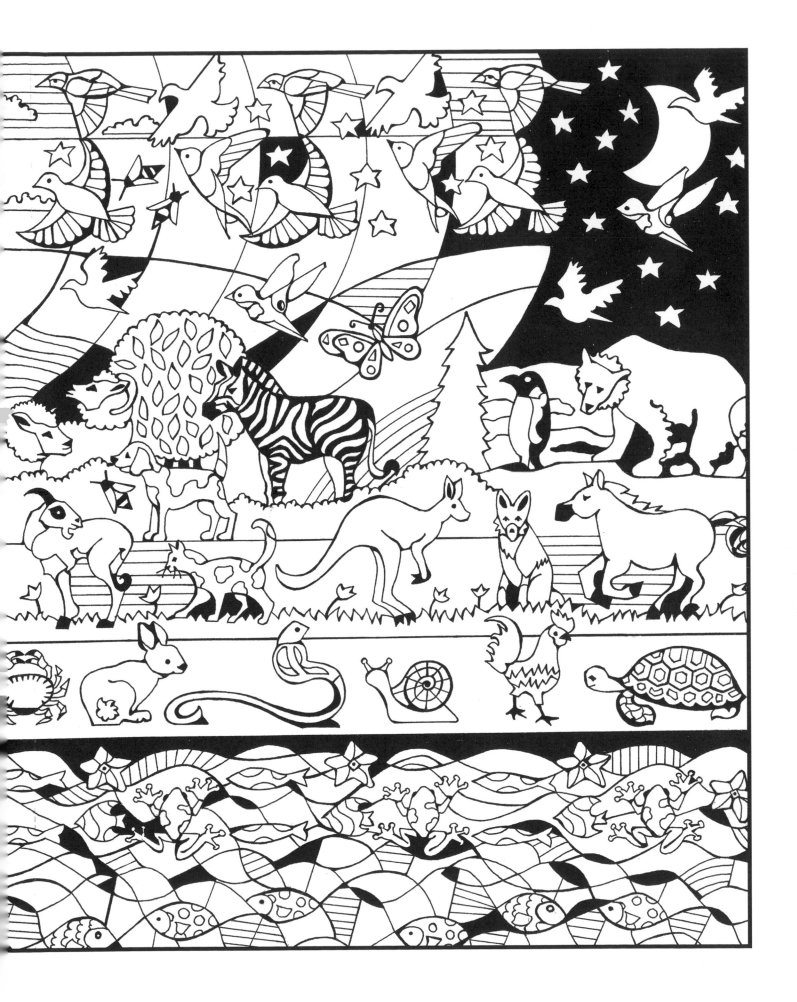

And Adam gave names to
all the cattle and to the birds of the sky
and to all the wild beasts. . . .

—Genesis 2:20

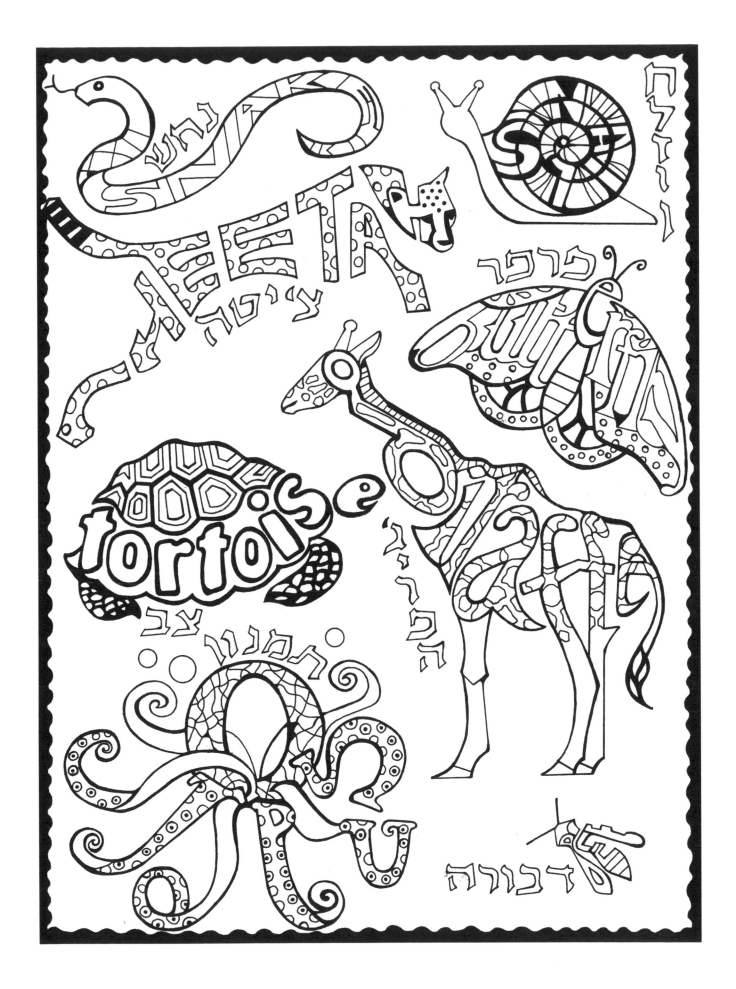

Now the serpent was the shrewdest
of all the wild beasts that God had made. . . .

—GENESIS 3:1

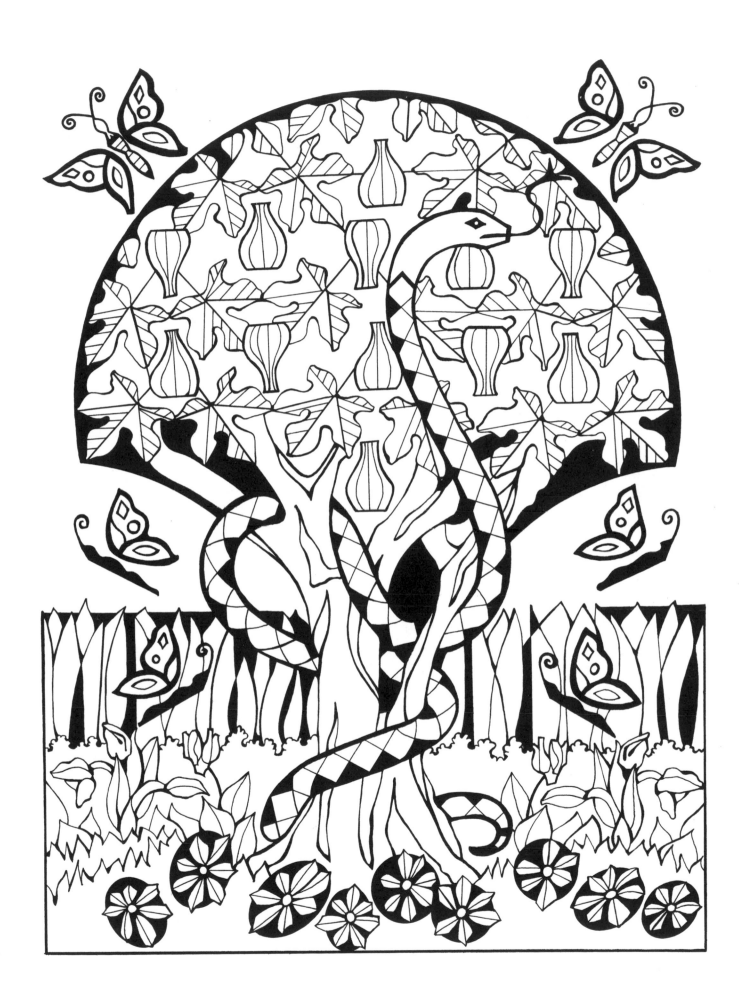

From birds of every kind,
animal of every kind, every kind of
creeping thing on earth, two of each shall
come to you to stay alive.

—GENESIS 6:20

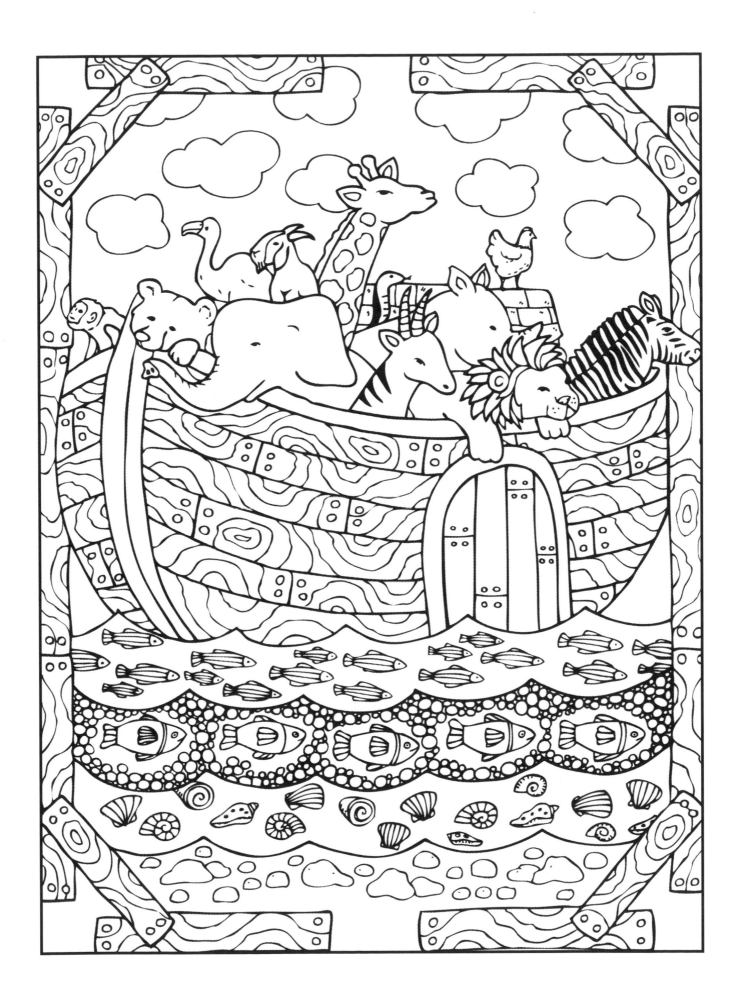

The dove came back [to Noah]
toward evening, and there in its beak was
a plucked-off olive leaf. . . .

—GENESIS 8:11

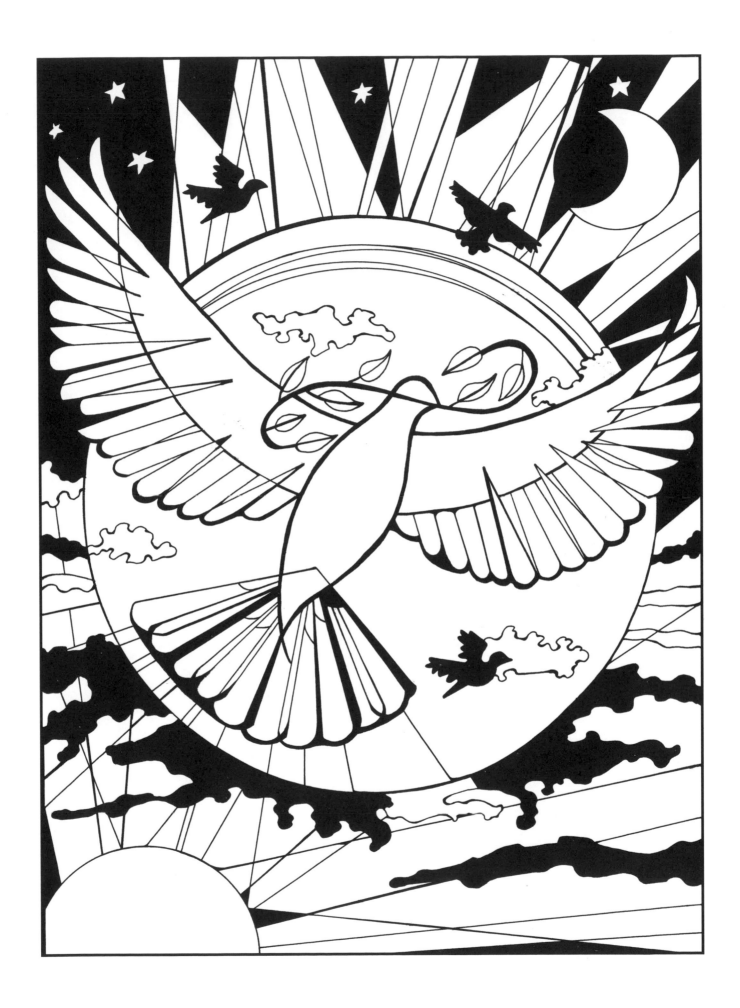

When Abraham looked up,
his eyes fell upon a ram, caught in
the thicket by its horns. . . .

—Genesis 22:13

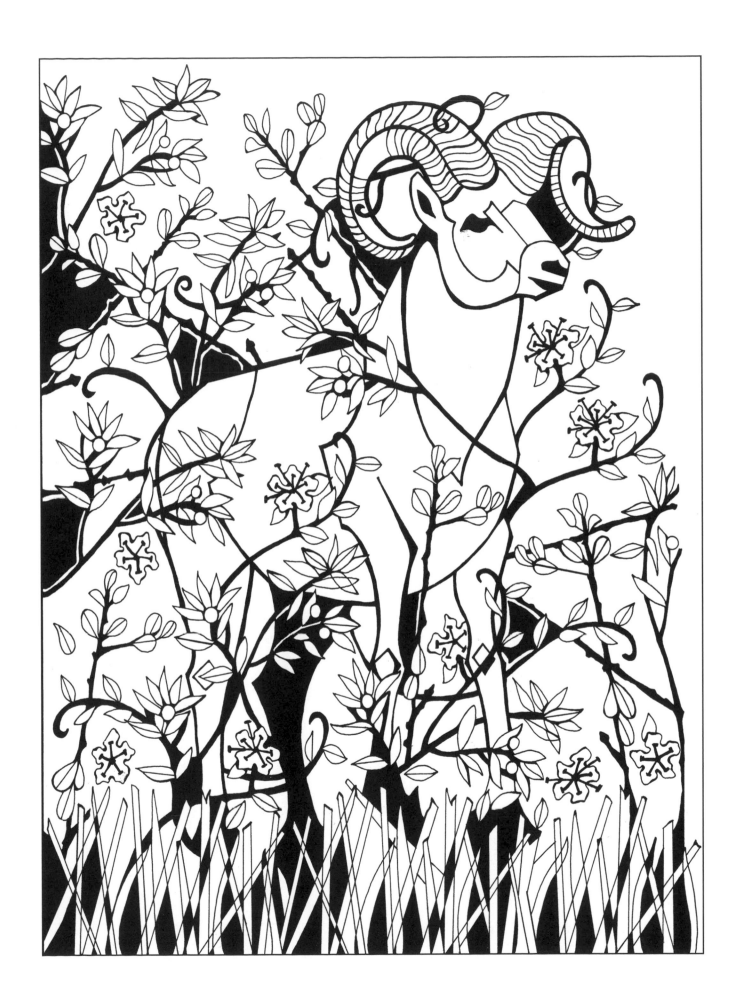

[Rebekah] quickly lowered her jar and said,
"Drink, and I will also water your camels."

—GENESIS 24:46

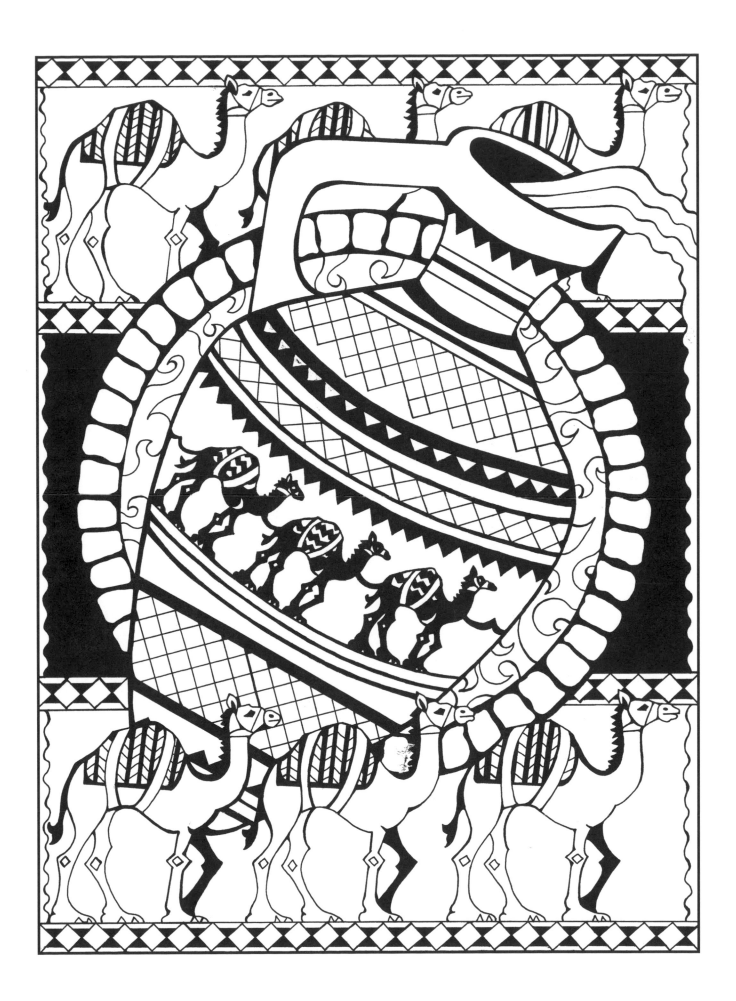

. . . Out of the Nile came up seven cows, handsome and sturdy, and they grazed in the reed grass. And then seven other cows came up from the Nile . . . ugly and gaunt. . . . And the ugly gaunt cows ate up the seven handsome sturdy cows. . . .

—GENESIS 41:2–4

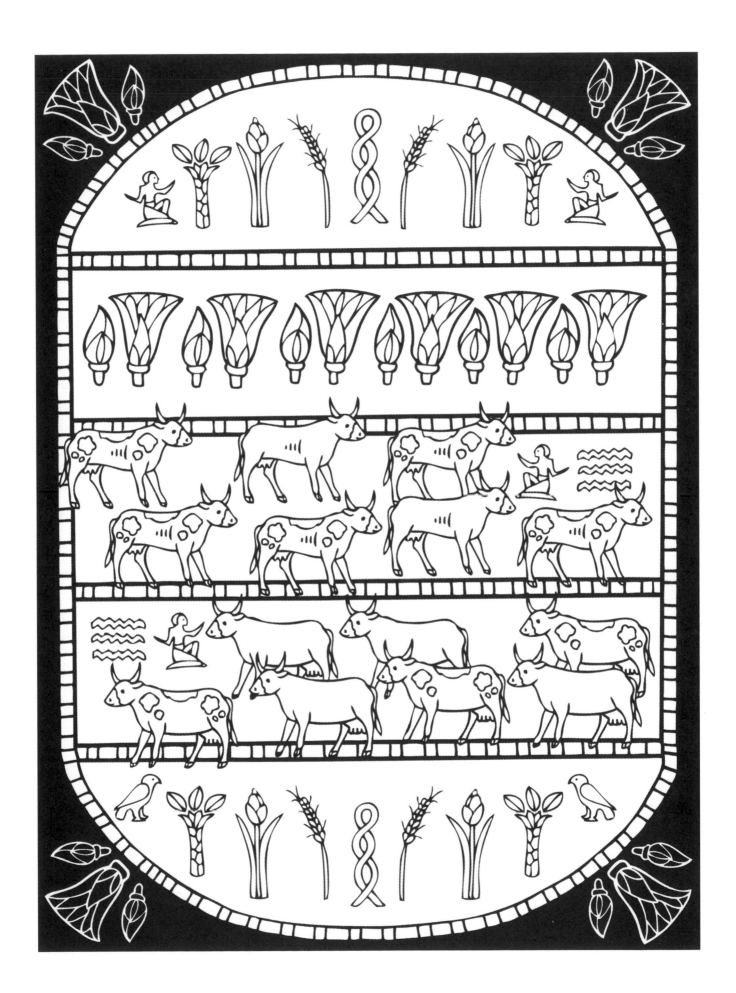

Judah is a lion's cub. . . .
He crouches, lies down like a lion.
Like the king of beasts—who dare rouse him?
The scepter shall not depart from Judah,
nor the ruler's staff from between his feet. . . .

—GENESIS 49:9–10

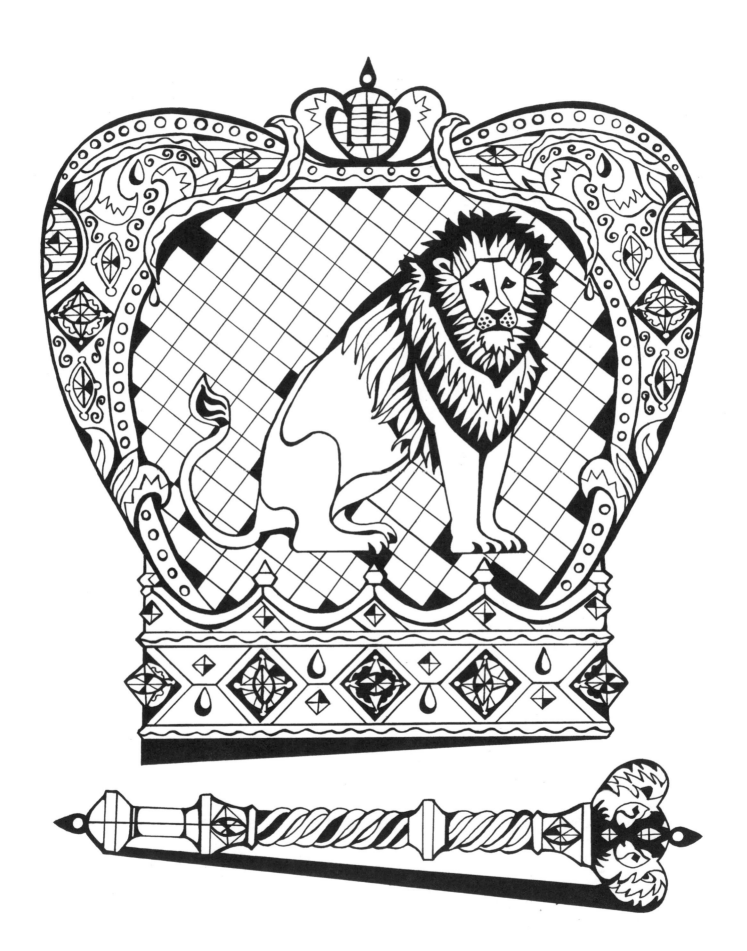

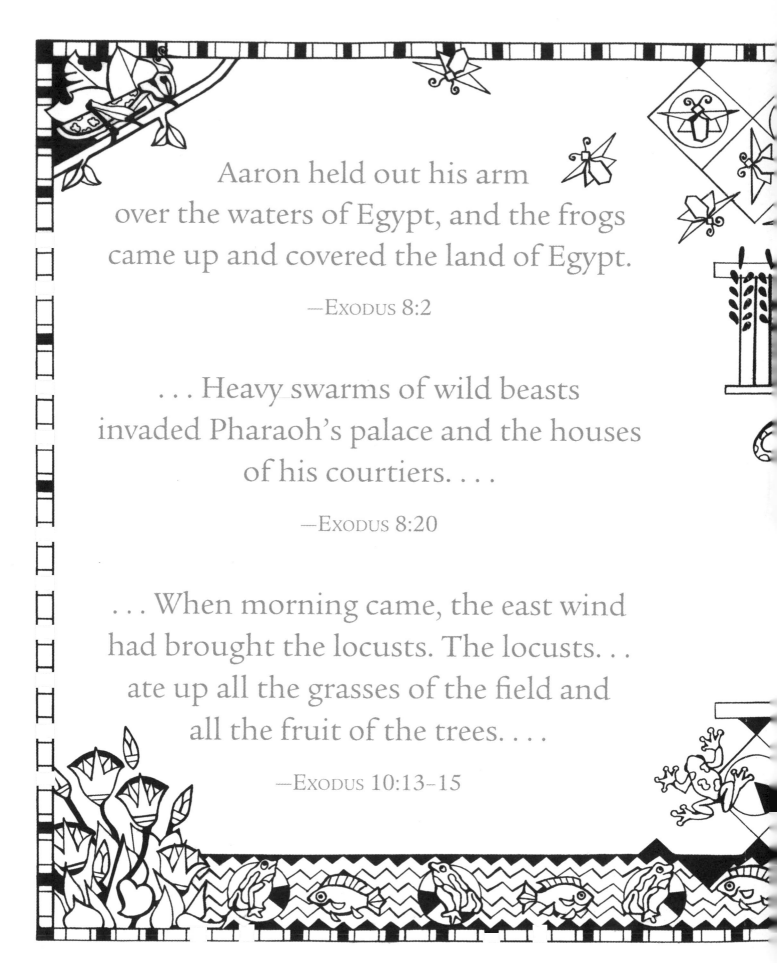

Aaron held out his arm
over the waters of Egypt, and the frogs
came up and covered the land of Egypt.

—Exodus 8:2

... Heavy swarms of wild beasts
invaded Pharaoh's palace and the houses
of his courtiers. ...

—Exodus 8:20

... When morning came, the east wind
had brought the locusts. The locusts...
ate up all the grasses of the field and
all the fruit of the trees. ...

—Exodus 10:13–15

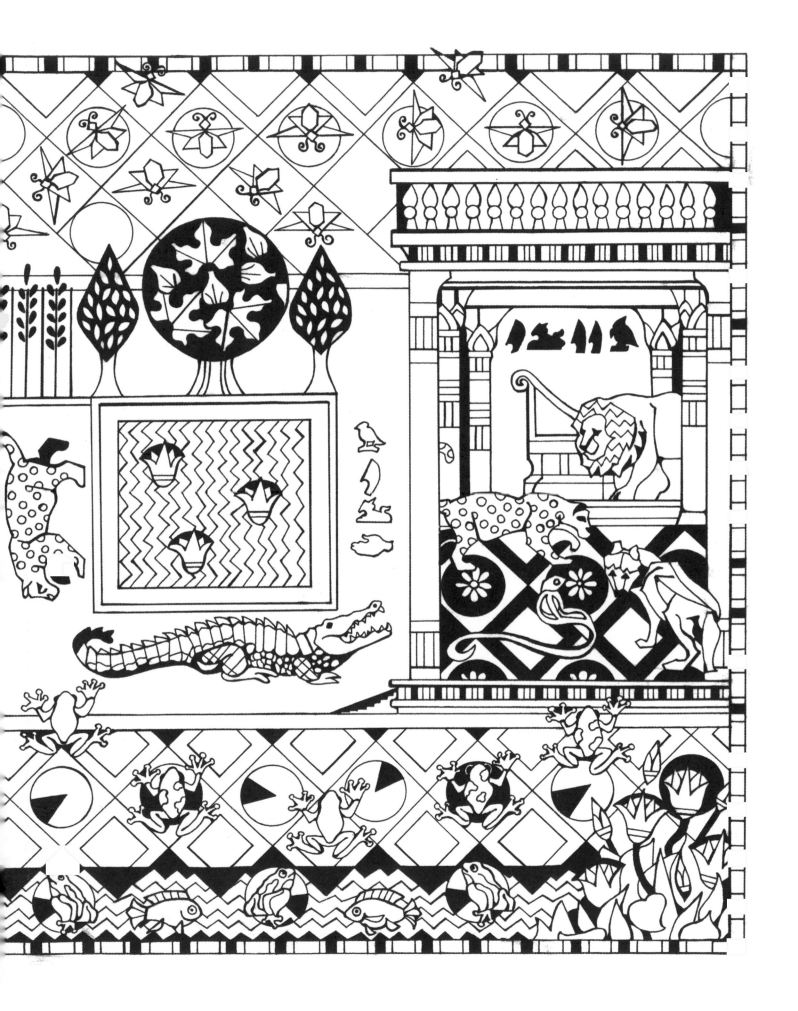

But not a dog shall snarl at
any of the Israelites, at man or animal. . . .

—Exodus 11:7

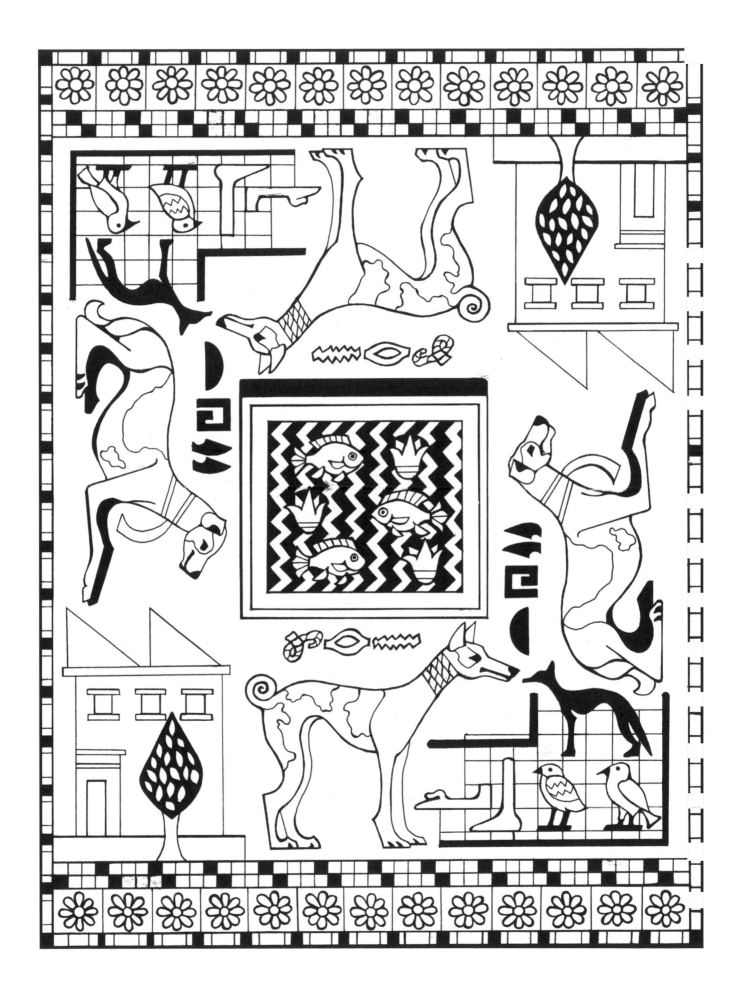

Then God opened the donkey's mouth,
and it said to Balaam . . . "I am
the donkey that you have been riding
all along until this day. . . ."

—NUMBERS 22:28–30

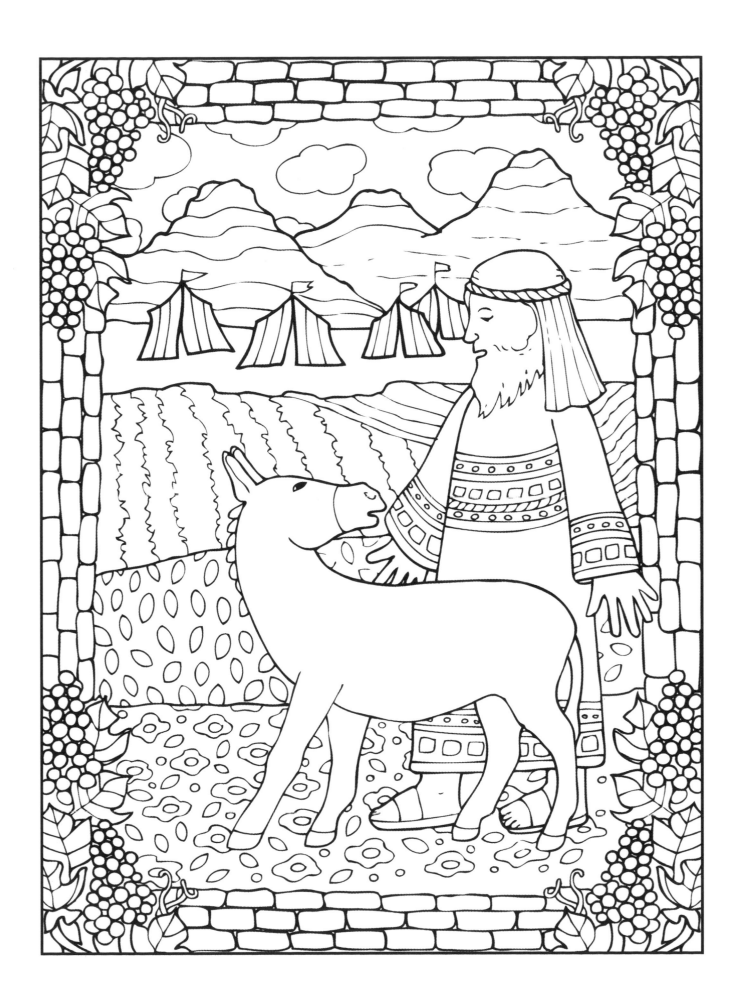

Like an eagle who rouses its nestlings,
gliding down to its young. . . .

—Deuteronomy 32:11

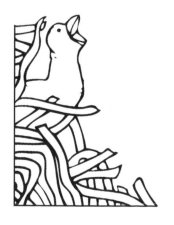

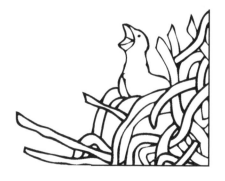

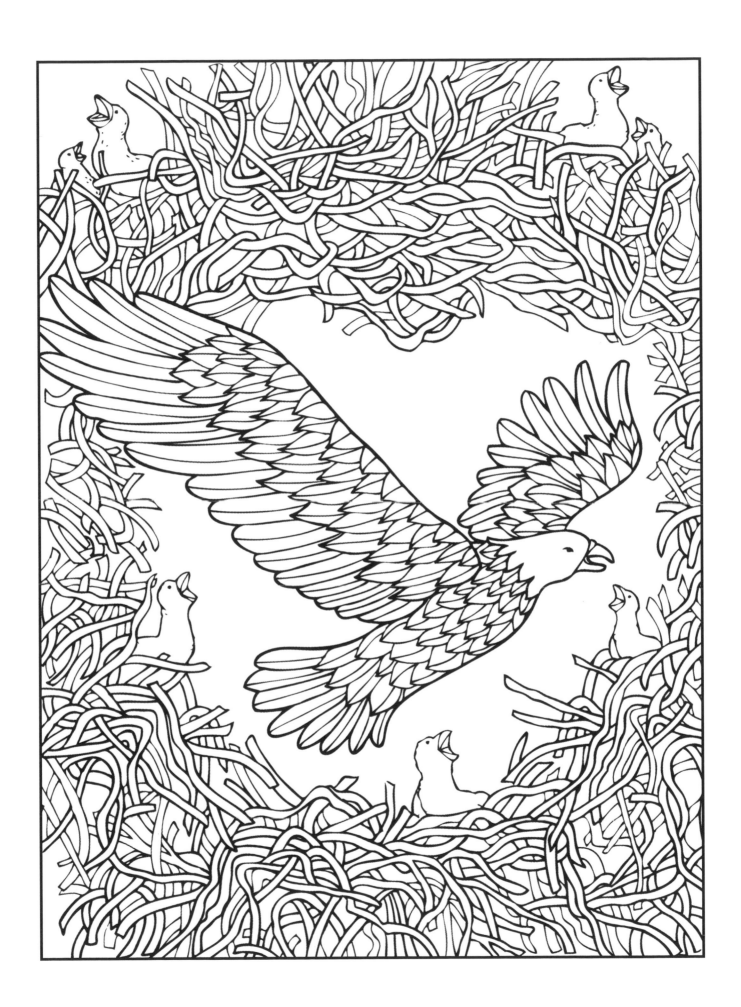

The ravens brought [Elijah] bread
and meat every morning and every evening. . . .

—1 Kings 17:6

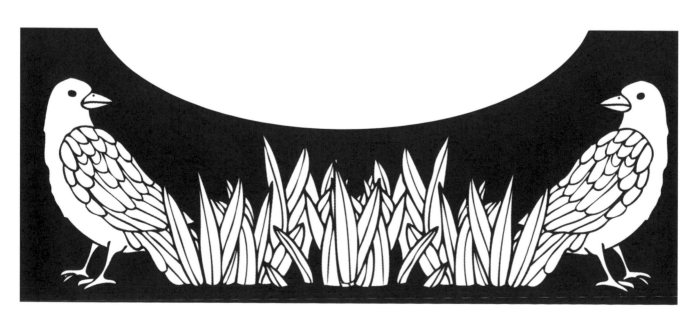

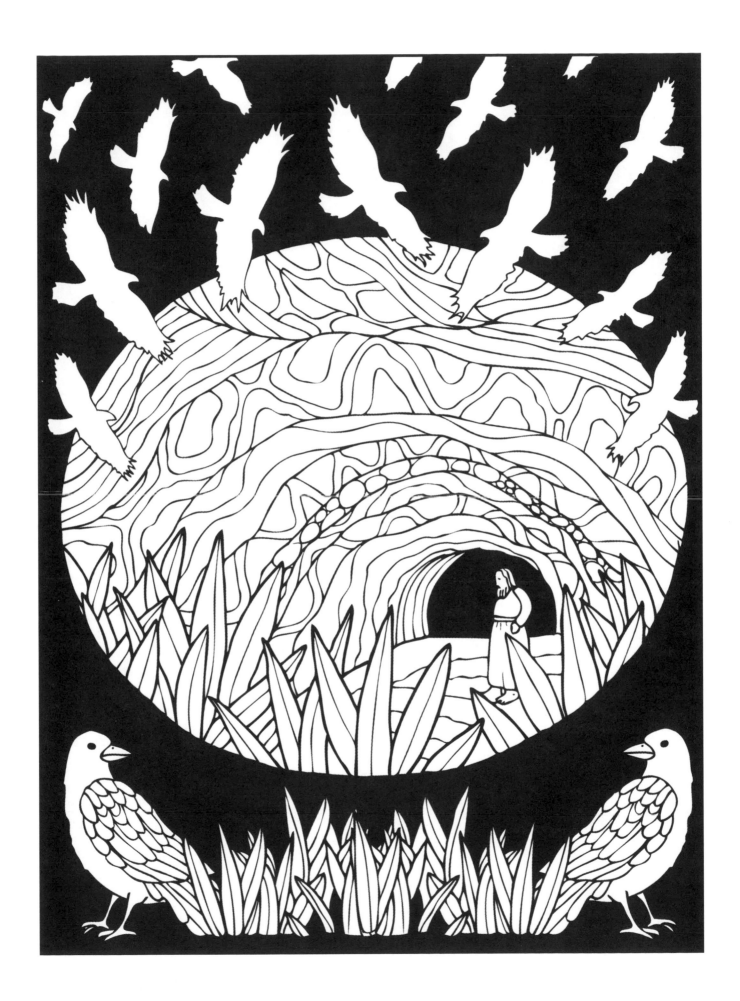

[Solomon] was wiser than all men. . . .
He spoke about beasts,
birds, creeping things, and fishes.

—1 Kings 5:11–13

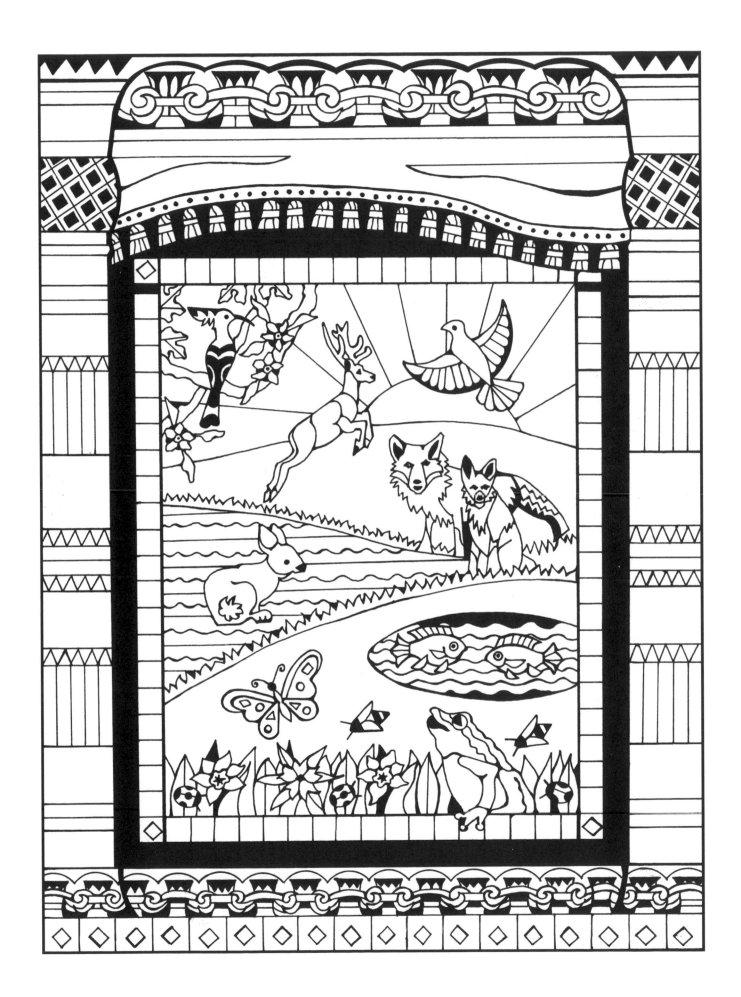

The queen of Sheba heard of
Solomon's fame. . . . She arrived in Jerusalem
with . . . camels bearing spices, a great quantity
of gold, and precious stones. . . .

—1 Kings 10:1–2

For [King Solomon] had a Tarshish
fleet on the sea. . . . Once every three years, the
Tarshish fleet came in, bearing gold and silver,
ivory, apes, and peacocks.

—1 Kings 10:22

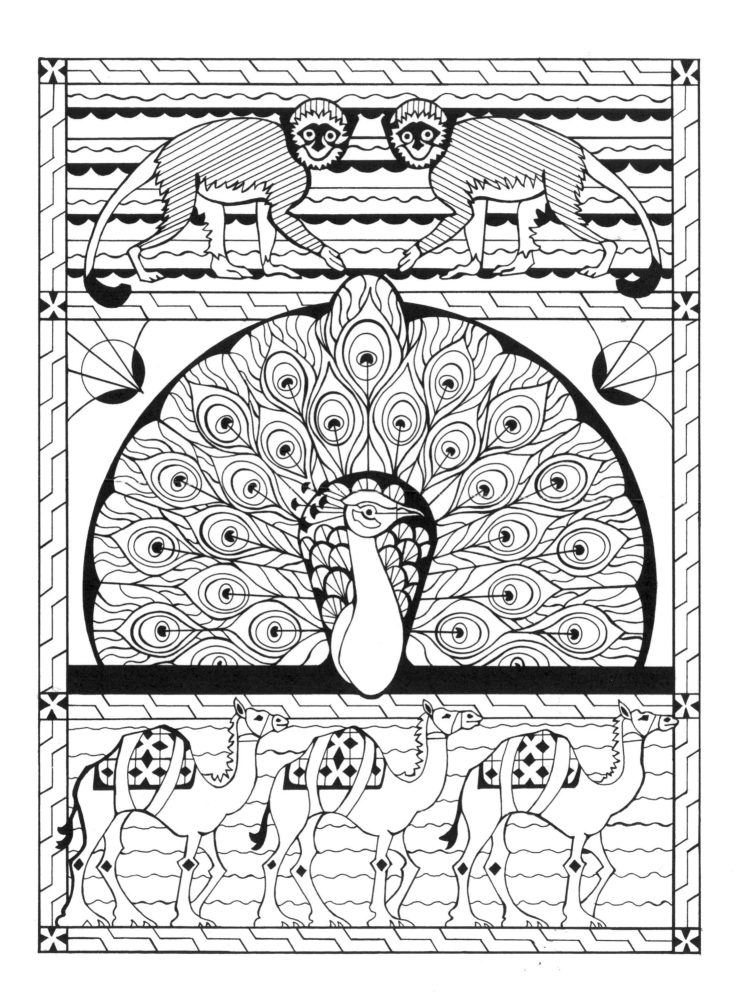

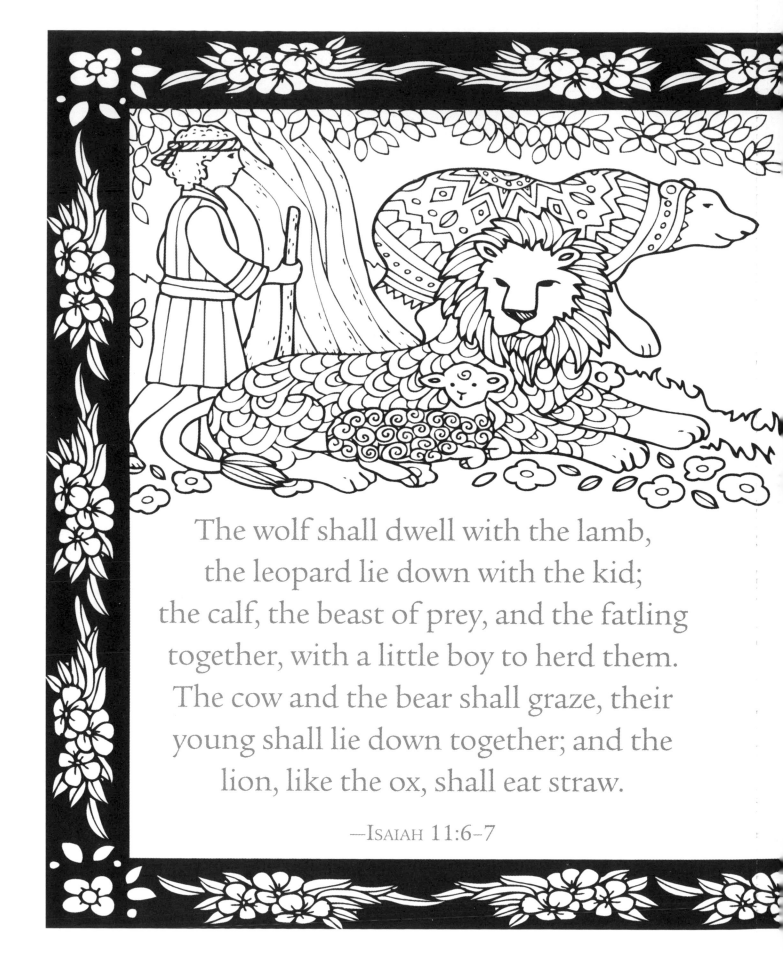

The wolf shall dwell with the lamb,
the leopard lie down with the kid;
the calf, the beast of prey, and the fatling
together, with a little boy to herd them.
The cow and the bear shall graze, their
young shall lie down together; and the
lion, like the ox, shall eat straw.

—ISAIAH 11:6–7

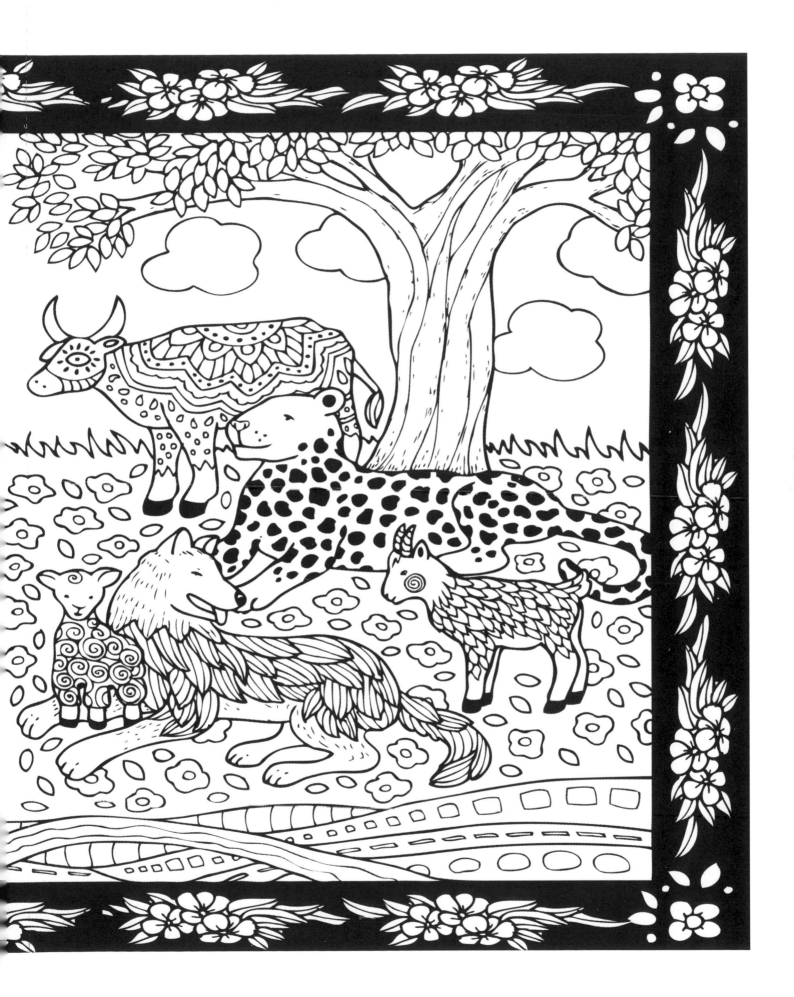

The wild beasts shall honor Me,
jackals and ostriches,
for I provide water in the wilderness,
rivers in the desert. . . .

—Isaiah 43:20

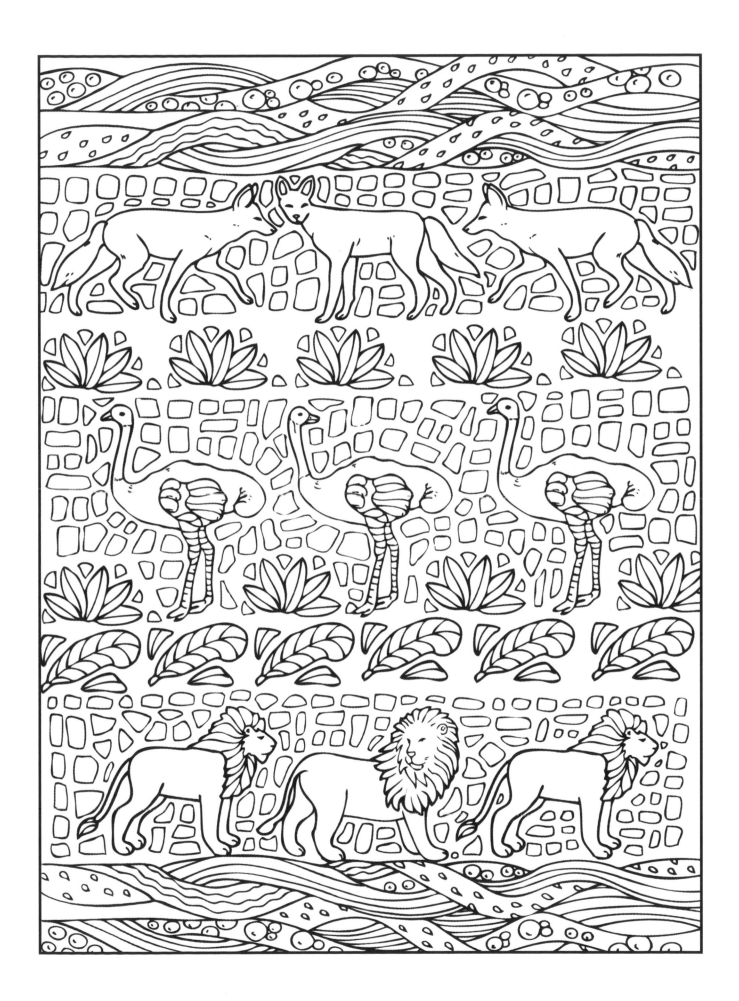

In its branches nested all the birds of the sky;
all the beasts of the field bore their young
under its boughs. . . .

—Ezekiel 31:6

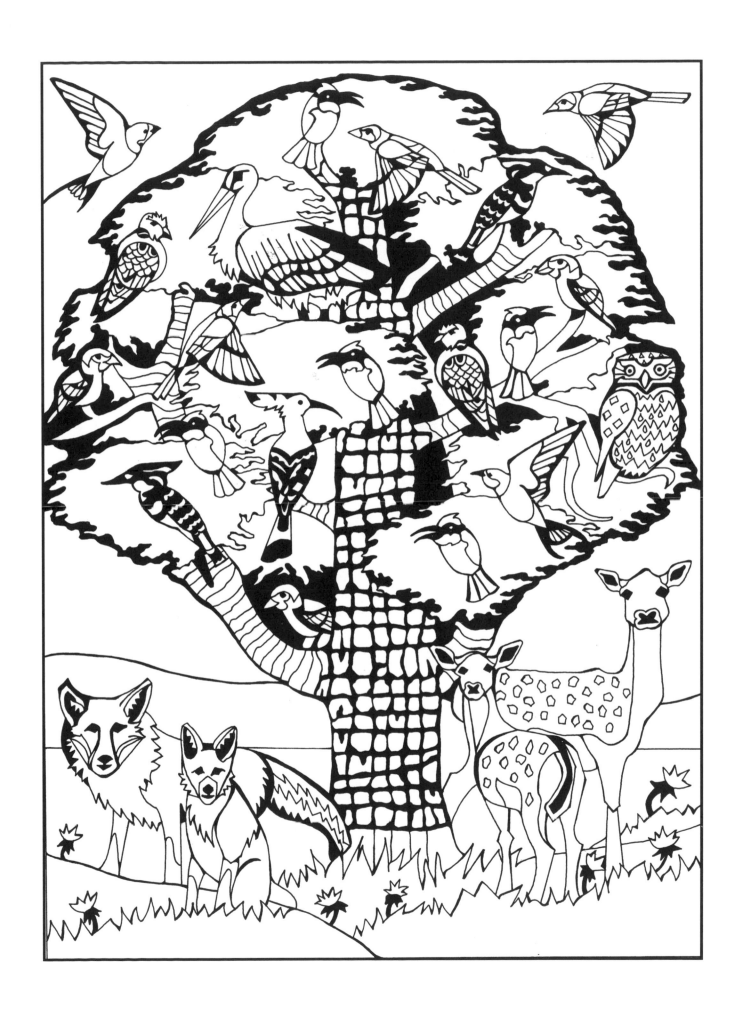

They shall flutter from Egypt like sparrows,
from the land of Assyria like doves;
and I will settle them in their homes. . . .

—Hosea 11:11

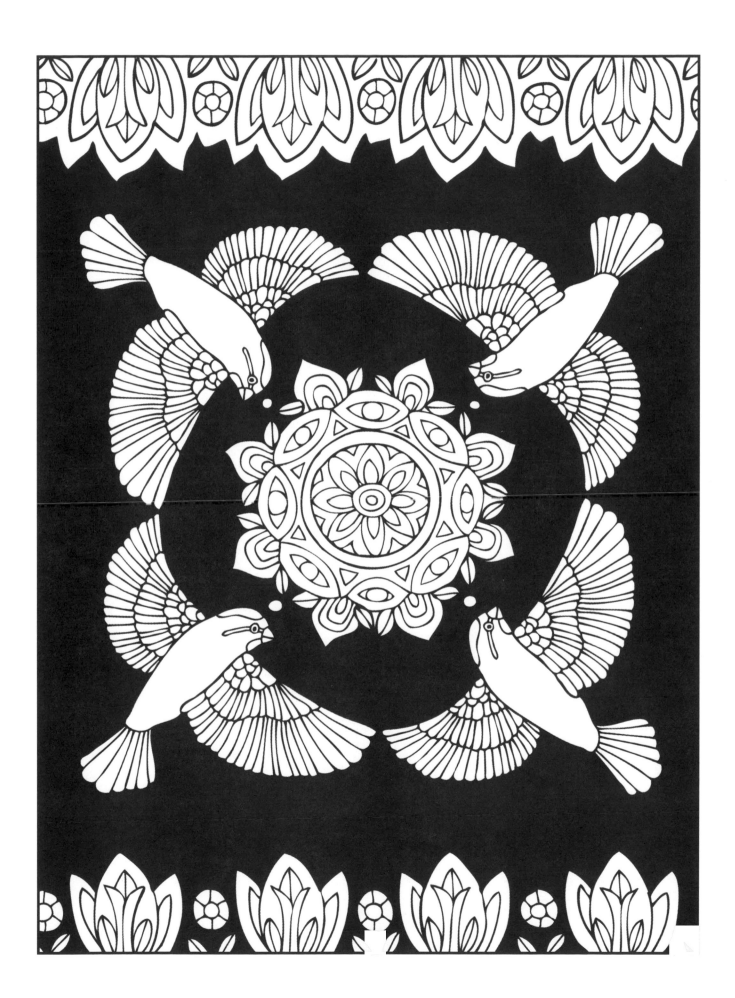

The Lord provided a huge fish to
swallow Jonah; and Jonah remained in
the fish's belly three days and three nights.
Jonah prayed to the Lord his God from
the belly of the fish.

—Jonah 2:1–2

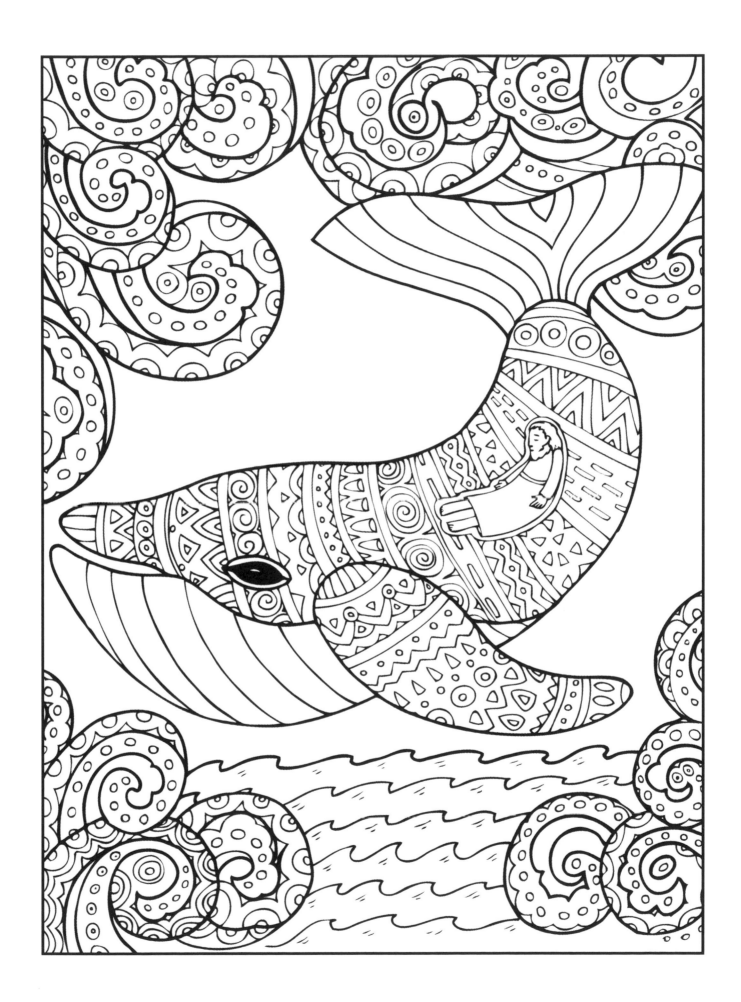

I will pray before God Most High,
the mighty one, who commanded
the spider who completed
a web for me.

—Targum Psalms 57:3

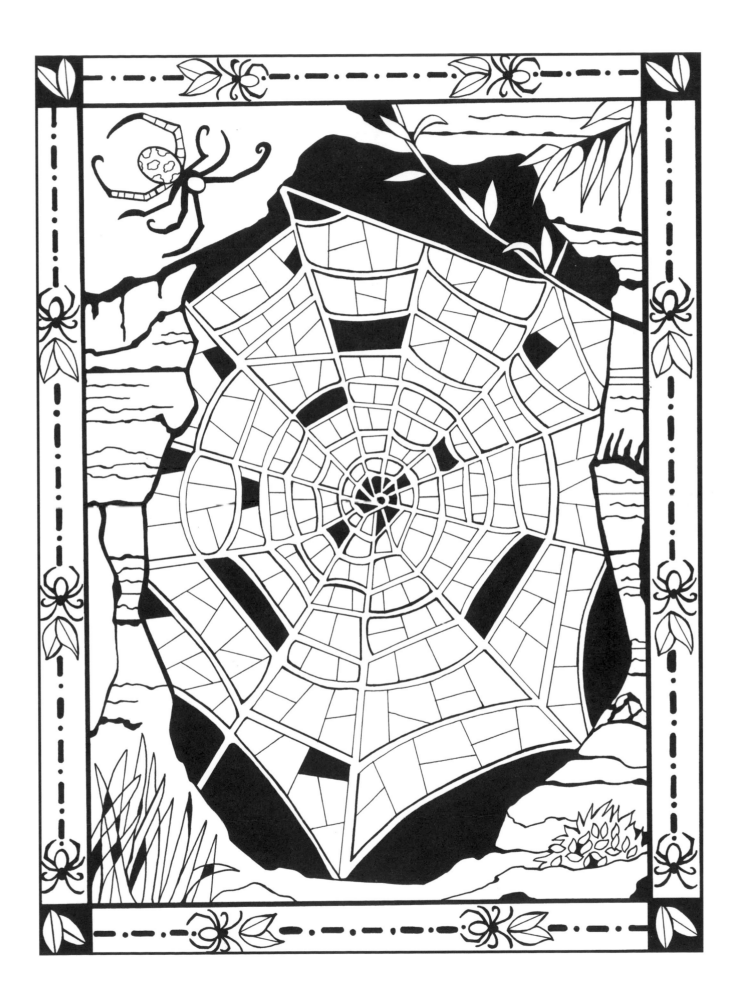

Even the sparrow has found
a home, and the swallow a nest for herself,
in which to set her young. . . .

—Psalms 84:4

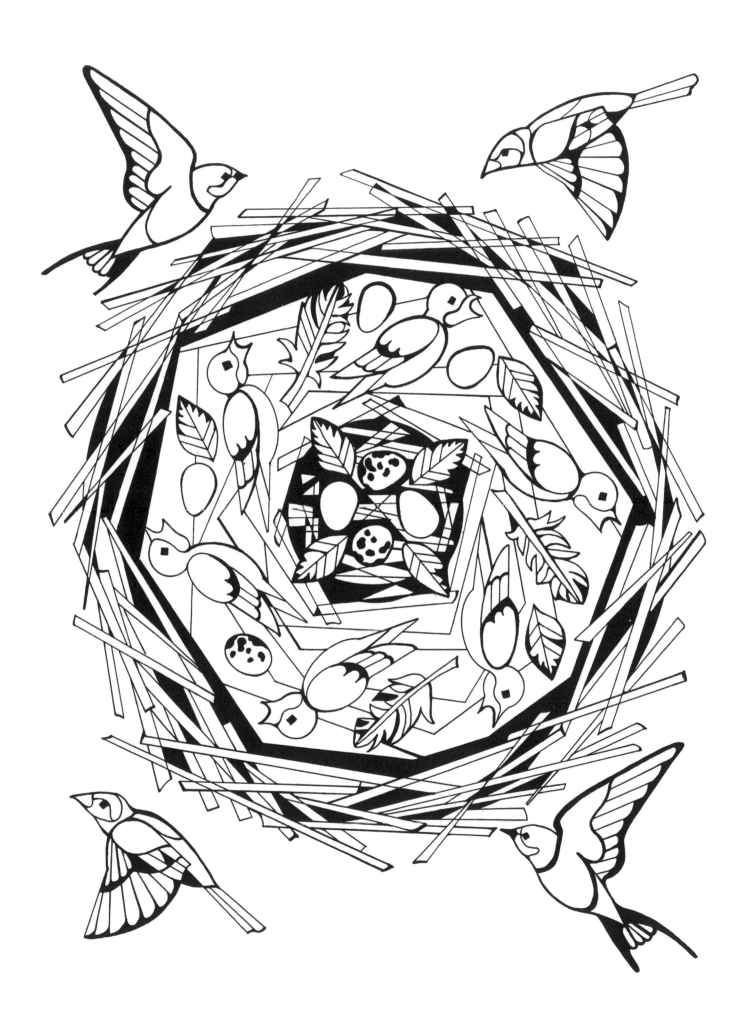

You bring on darkness and it is night,
when all the beasts of the forests stir.

—Psalms 104:20

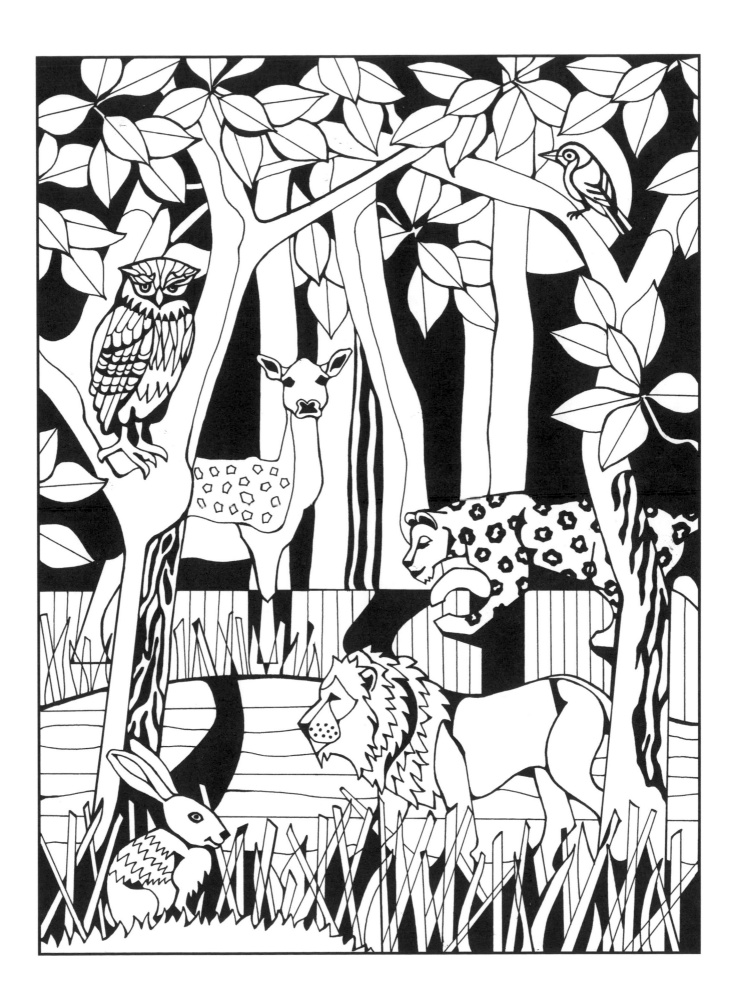

There is the sea, vast and wide,
with its creatures beyond number, living things,
small and great. There go the ships,
and the Leviathan that You formed to play with.

—Psalms 104:25–26

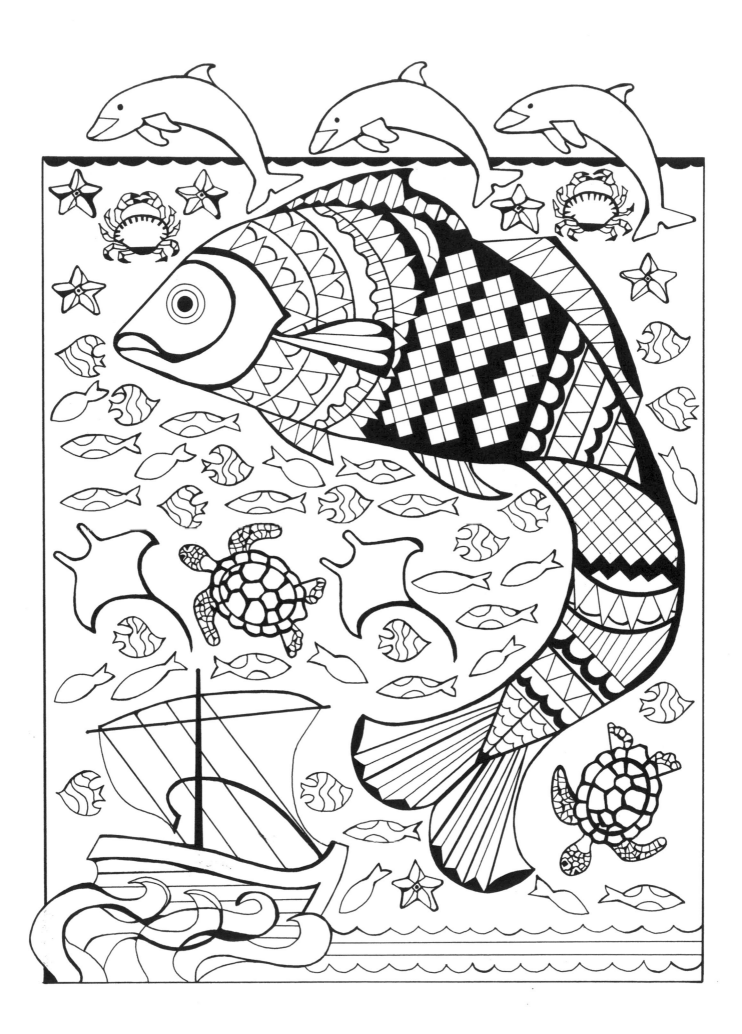

Go to the ant, you sluggard;
study its ways and learn.
Without leaders, officers, or rulers,
it lays up its stores during the summer,
gathers in its food at the harvest.

—Proverbs 6:6–8

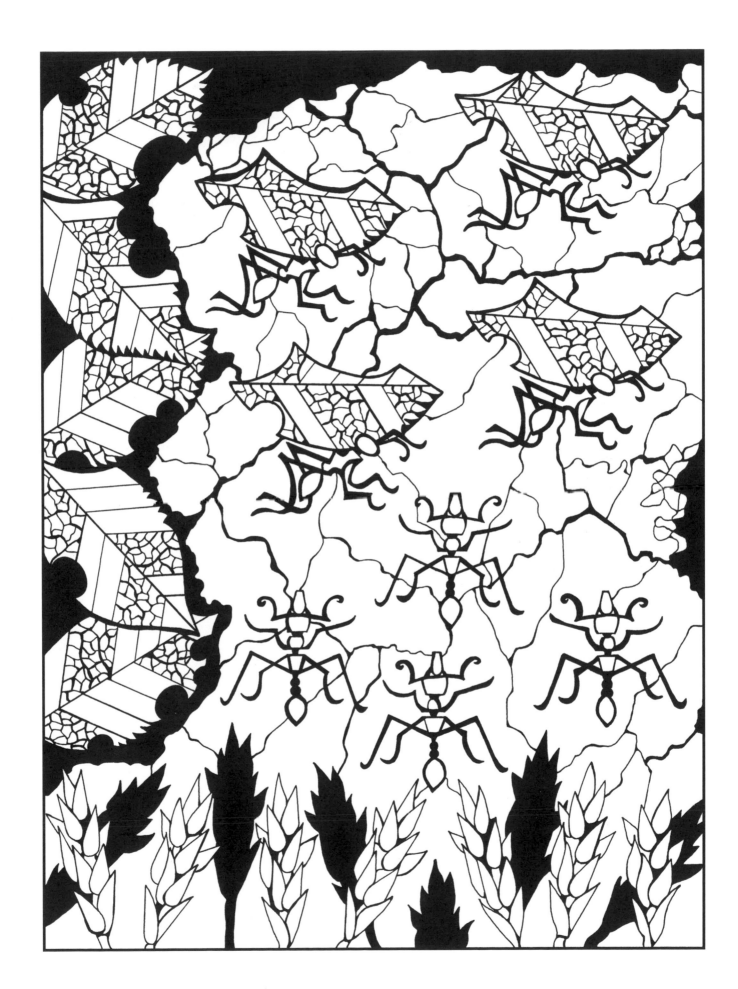

Ants are a folk without power,
yet they prepare food for themselves in summer.
The stone badger is a folk without strength,
yet it makes its home in the rock.

—PROVERBS 30:25–26

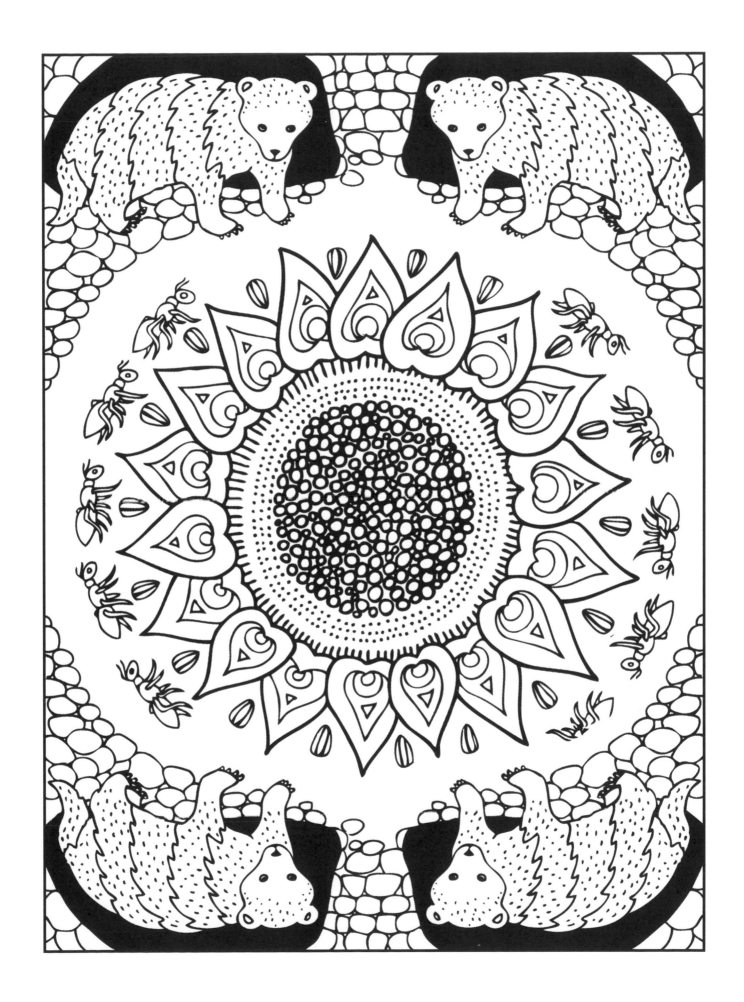

The locusts have no king,
yet they all march forth in formation.
You can catch the lizard in your hand,
yet it is found in royal palaces.

—PROVERBS 30:27–28

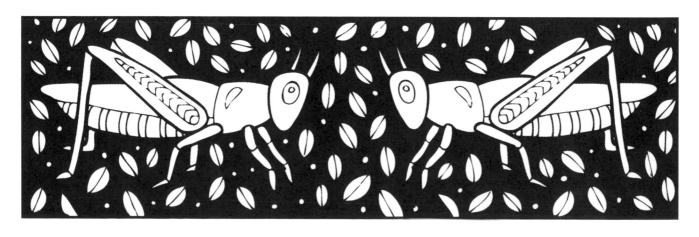

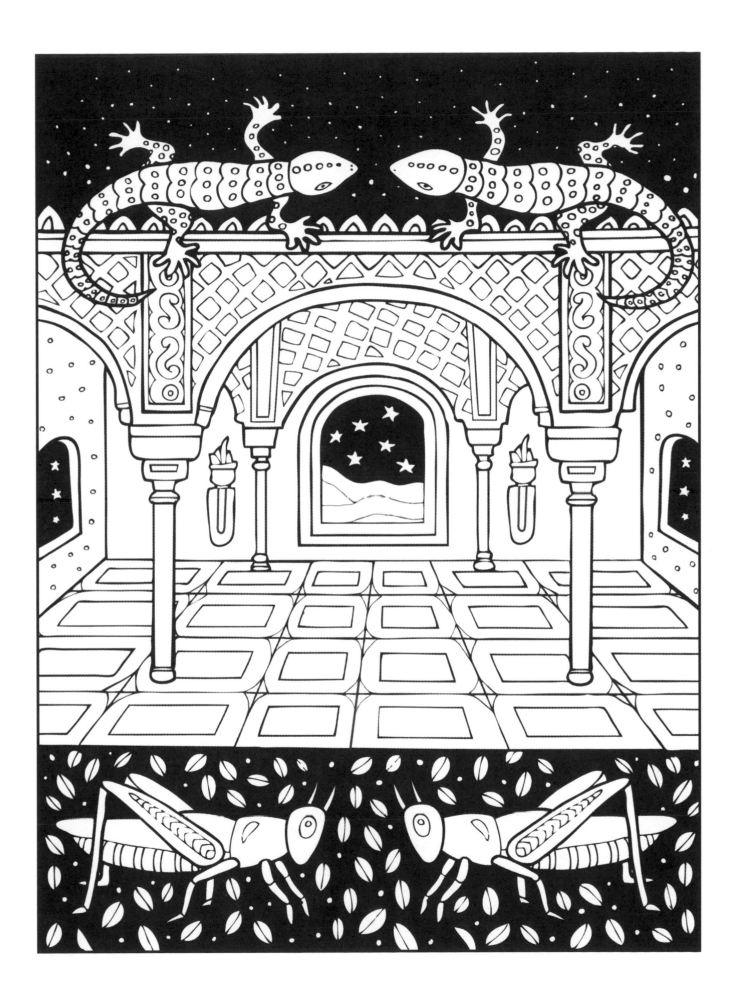

Hark! My beloved!
There he comes,
leaping over mountains,
bounding over hills.
My beloved is like a gazelle,
or like a young stag. . . .

—Song of Songs 2:8–9

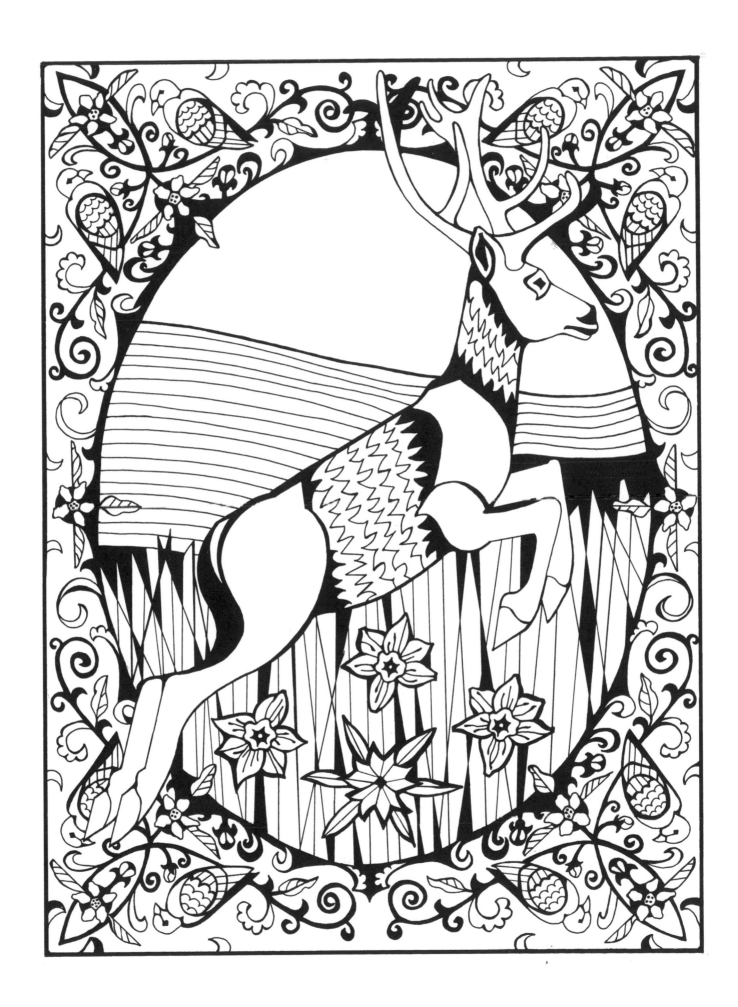

The blossoms have appeared in the land,
the time of singing has come;
the song of the turtledove
is heard in our land.

—SONG OF SONGS 2:12

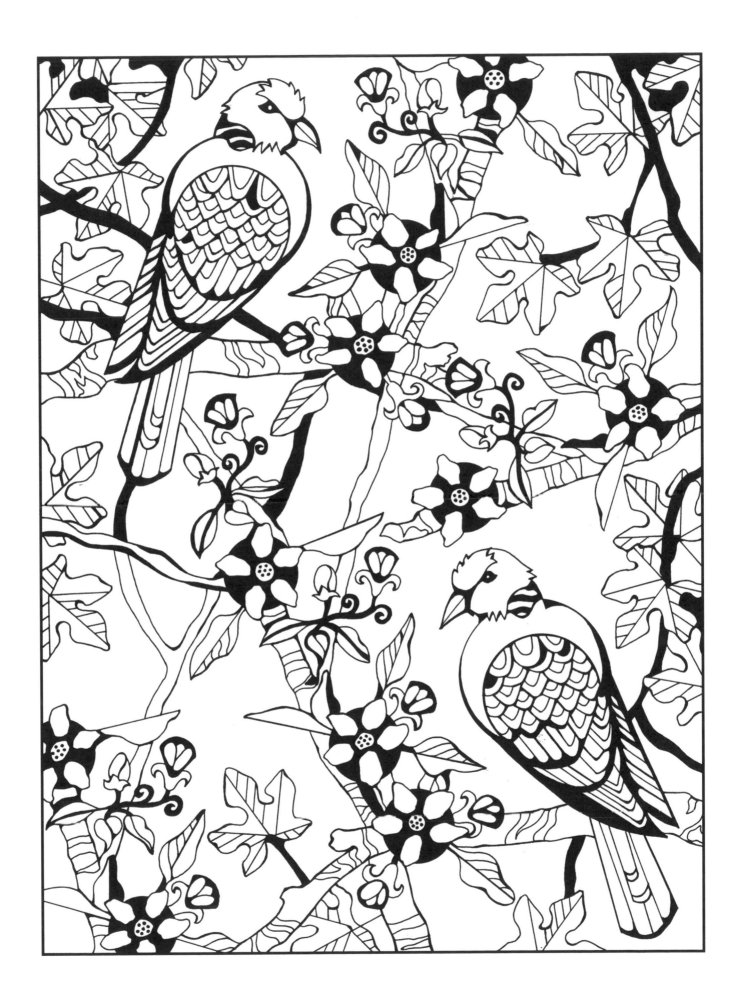

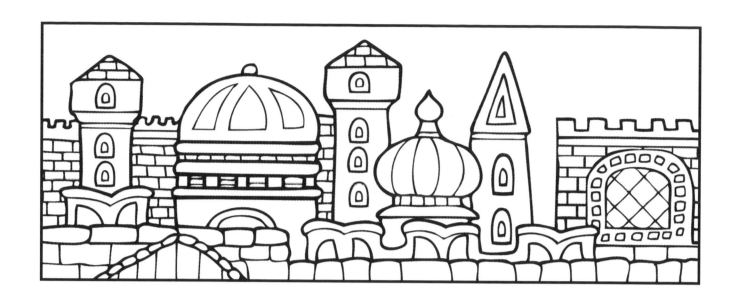

So Haman took the garb and
the horse and dressed Mordecai and paraded
him through the city square; and he proclaimed
before him: This is what is done for the man
whom the king desires to honor!

—ESTHER 6:11

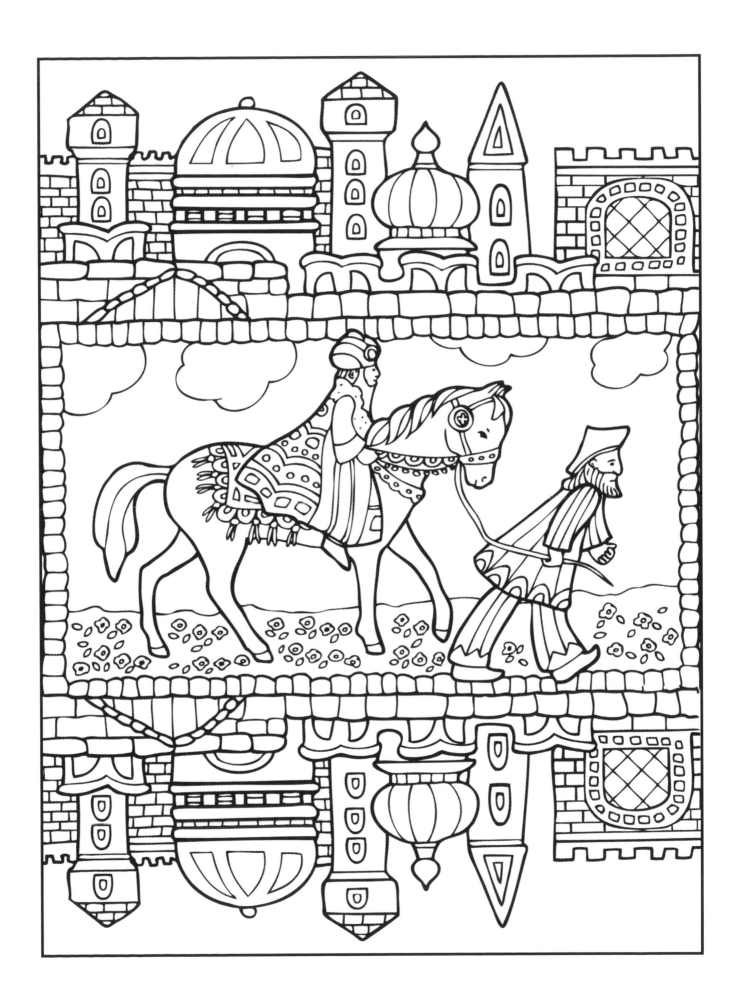

. . . [God] delivered Daniel from
the hands of the lions.

—DANIEL 6:28

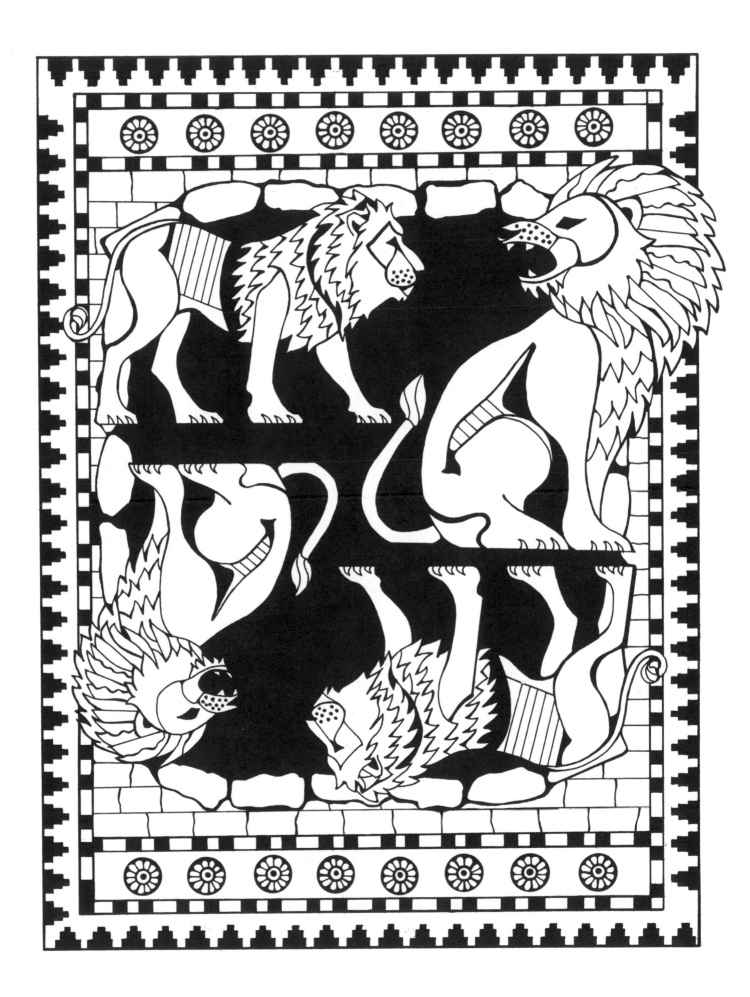

. . . Let every creature praise God's
holy name forever and ever.

—Psalms 145:21

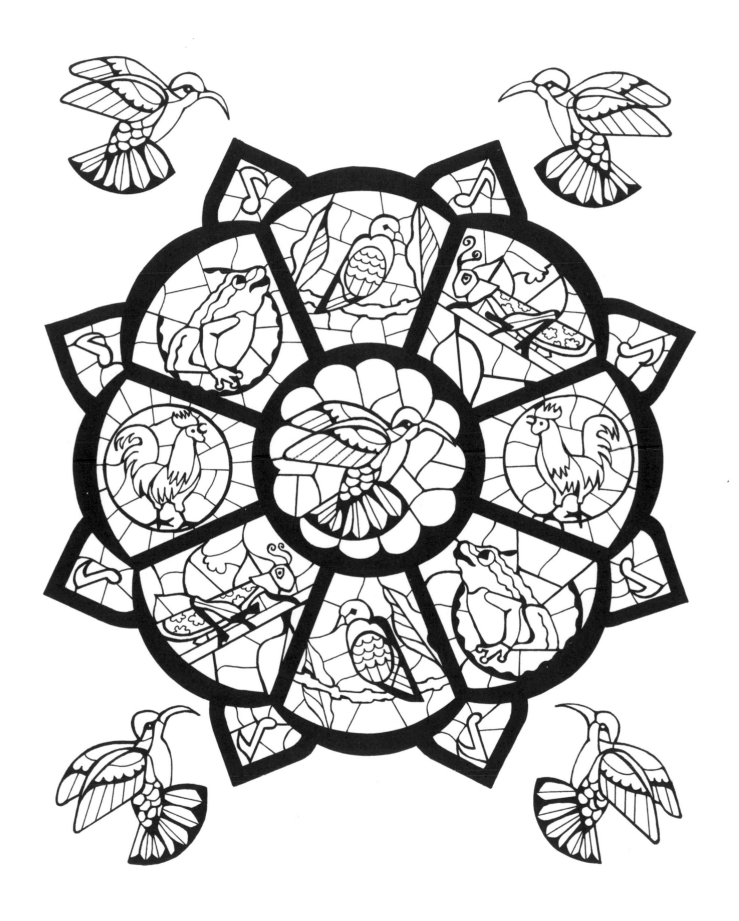